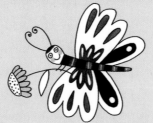

DRAW IT HAPPY!

100+ FUNNY ANIMALS AND FANTASTIC CHARACTERS

Terry Runyan

QUARRY

CONTENTS

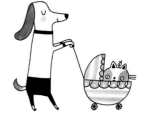

Introduction 3

Characters

Animals

INTRODUCTION

I'm kind of obsessed with drawing animals. As a kid I primarily drew horses and dogs, but as I continued to create more illustrations, particularly for myself, cats became a dominant theme. I've also always considered myself a character artist of sorts. Most of the time something feels missing if there isn't a character in the mix. Because of these two factors, I love creating fun stories with characters, and of course making them cute!

Use this book as a guide and reference to develop your own unique characters and animals. Use the steps to learn about and practice each subject's basic shapes and characteristics. You can start with the facial features—eyes, nose, and mouth—then work your way through the drawing, adding details and other features to make the character unique. You can add the head shape, ears, body shape, and clothing or distinguishing marks. Once you have the basic shapes and details down, try drawing the animal or character in different variations and situations, then maybe add some friends to help tell a story.

Although I created the drawings in this book digitally, I recommend that you try as many mediums as you can—pencils, colored pencils, crayons, pens, cut paper, paints, and digital platforms—to see which are most fun for you. This kind of exploration will help you develop your own style of drawing.

Remember, taking time to draw often, even daily, is the best way to become more skilled at drawing. Giving yourself time to draw makes all the difference, not only in improving your skills but in igniting your creativity. Drawing is a wonderful way to experiment, have fun, and enjoy a bit of happy!

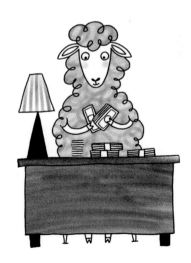

DRAW A BASEBALL BAT

DRAW A SUPERHERO SLOTH

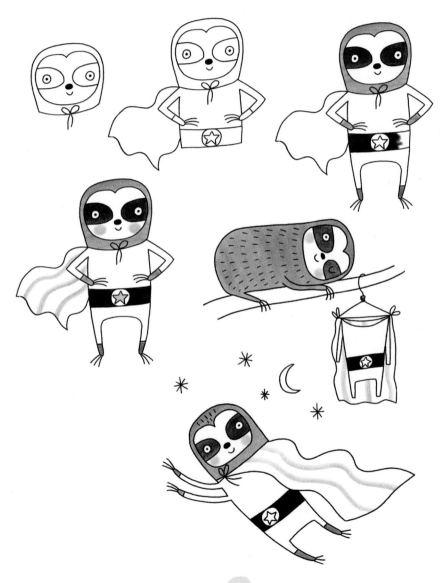

DRAW A SWEET TOOTH

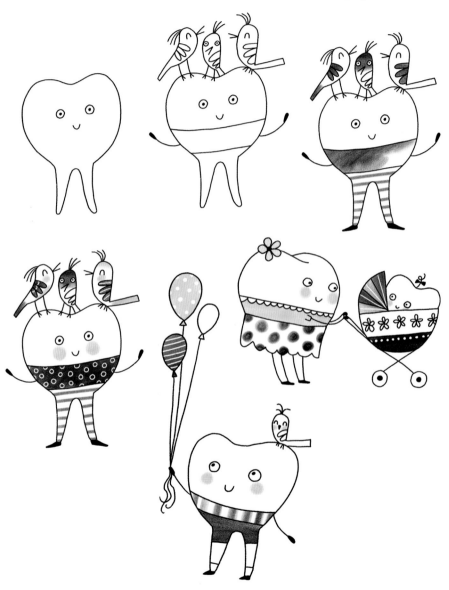

DRAW A BEACH BUM

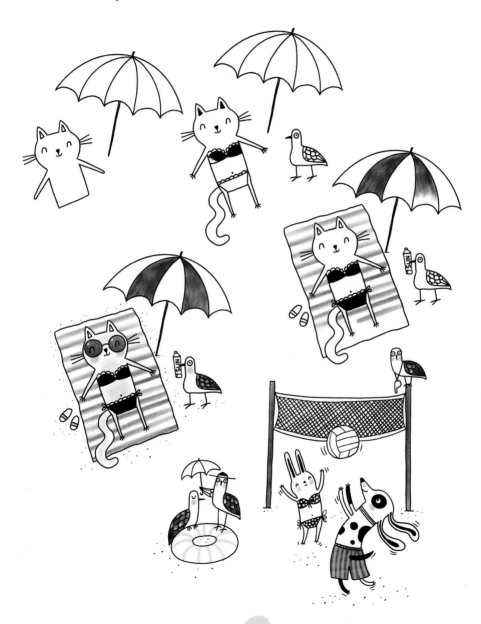

DRAW A TEA TIMER

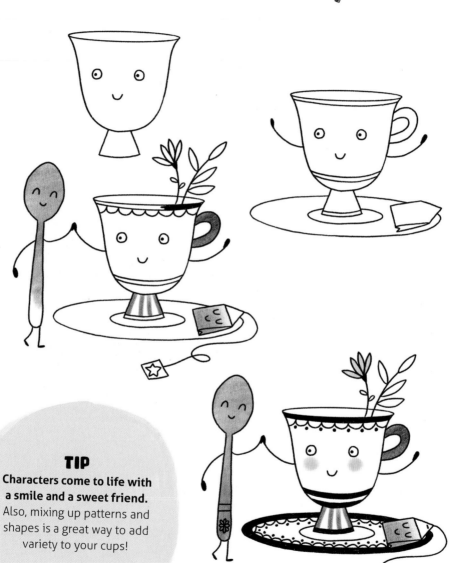

TIP
Characters come to life with a smile and a sweet friend. Also, mixing up patterns and shapes is a great way to add variety to your cups!

DRAW A BIRD WATCHER

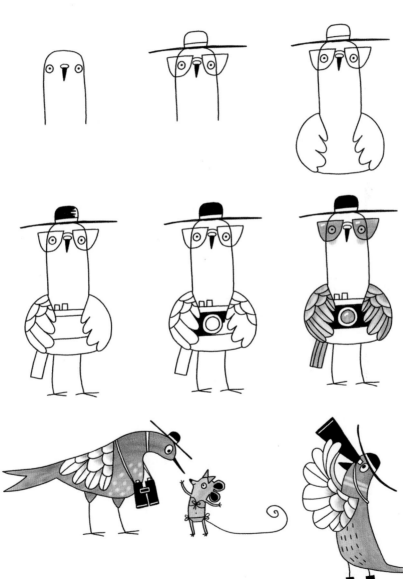

DRAW A PARTY MONSTER

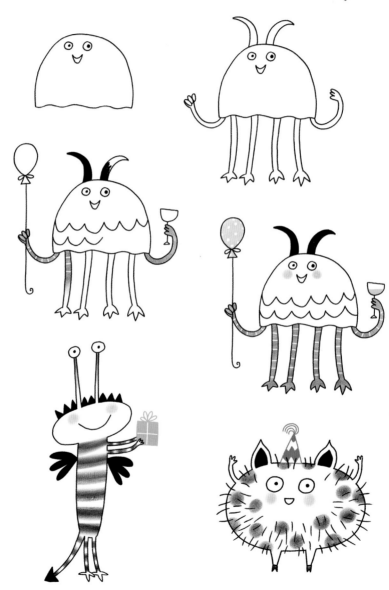

DRAW A FELINE FASHIONISTA

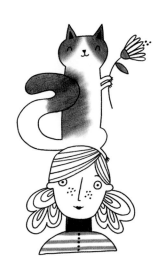

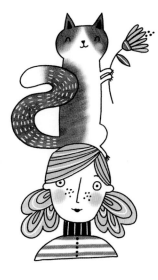

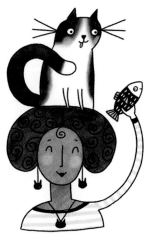

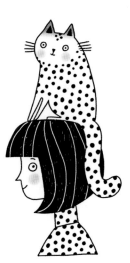

DRAW A DRUM MAJOR

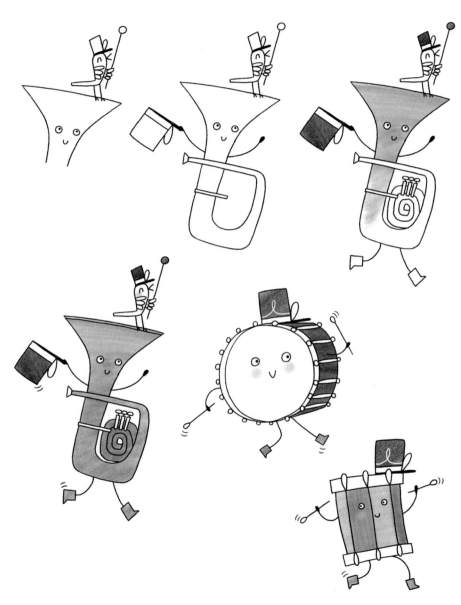

DRAW A BABYSITTER

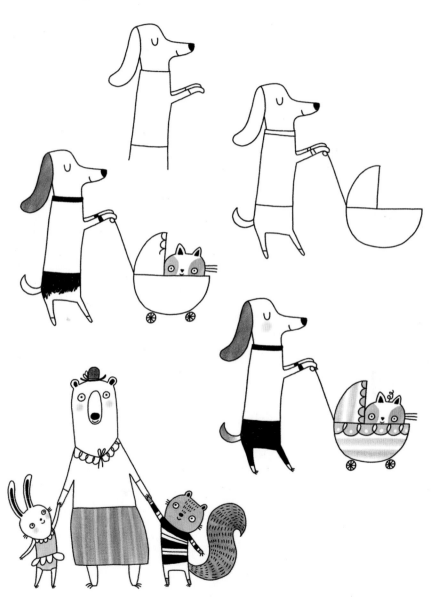

DRAW A FRUIT LOVER

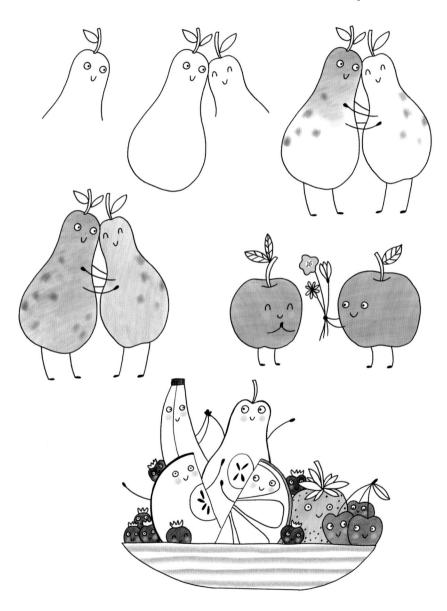

DRAW AN OFFICE MONKEY

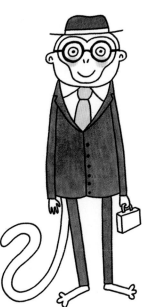

DRAW A TIPSY TUMBLER

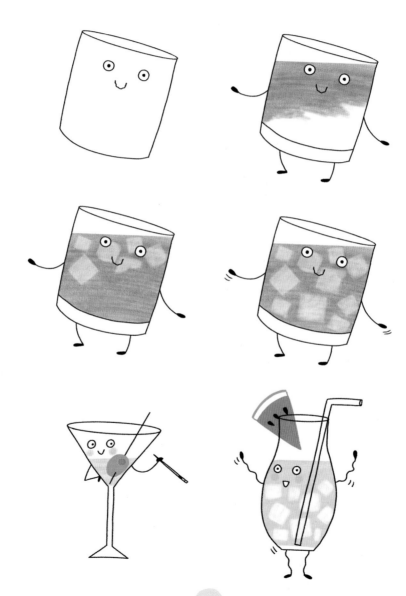

DRAW AN AIRY FAIRY

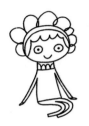
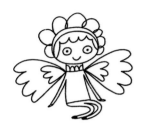

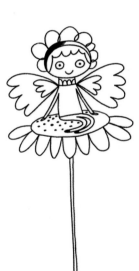
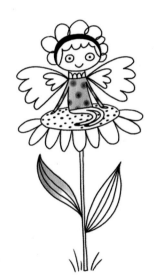

DRAW A BUSY BEAVER

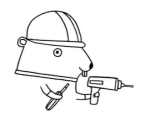

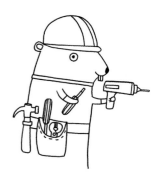

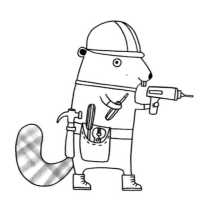

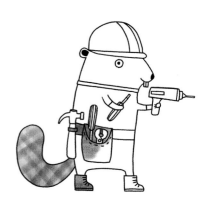

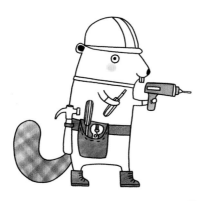

TIP

How would a human work on the job? What equipment and supplies do they use? Answering questions like these while drawing a busy beaver can make for a happy workplace.

DRAW A FAST FOODIE

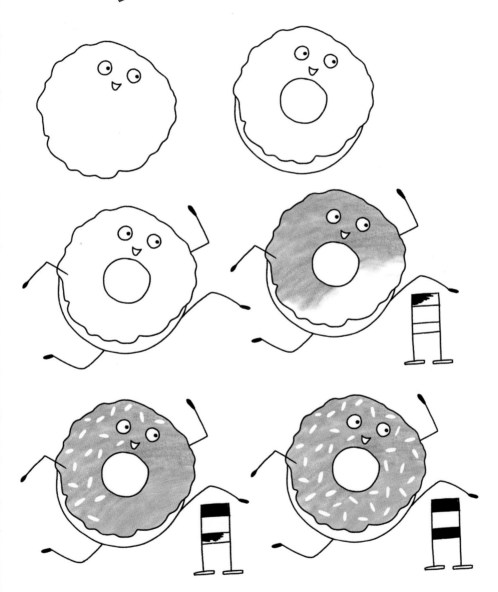

DRAW A MINI MAGICIAN

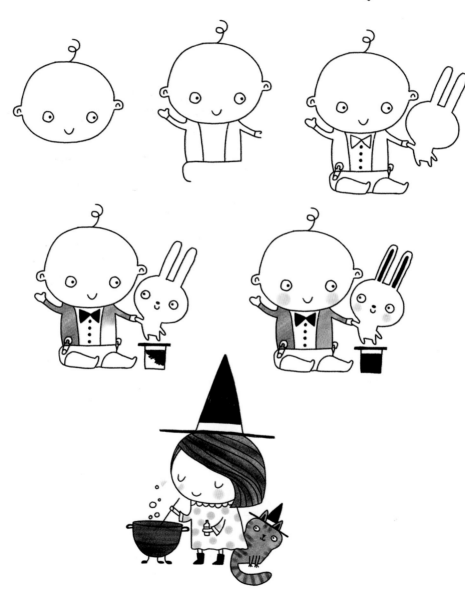

DRAW A NIGHT OWL

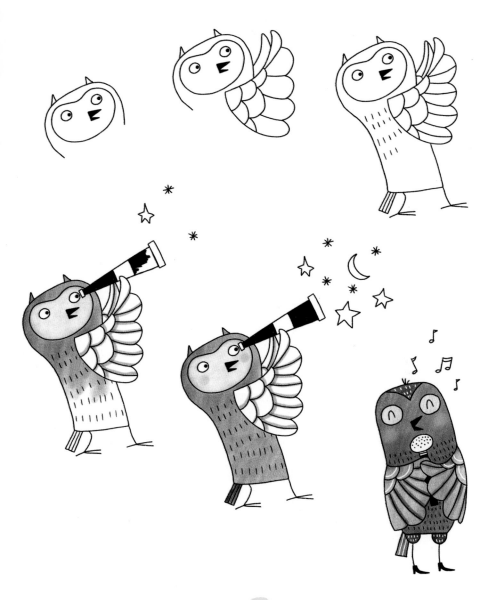

DRAW A CLASSROOM CHARACTER

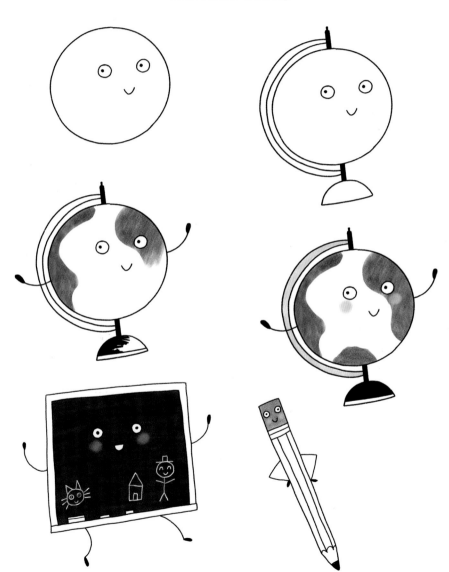

DRAW A DINO DUDE

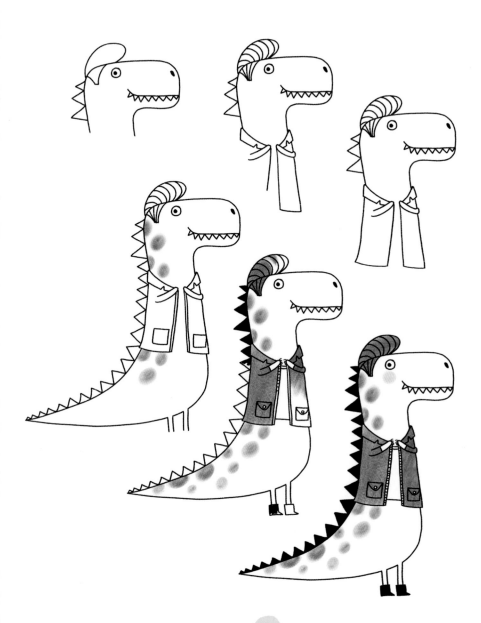

DRAW A GHOST WRITER

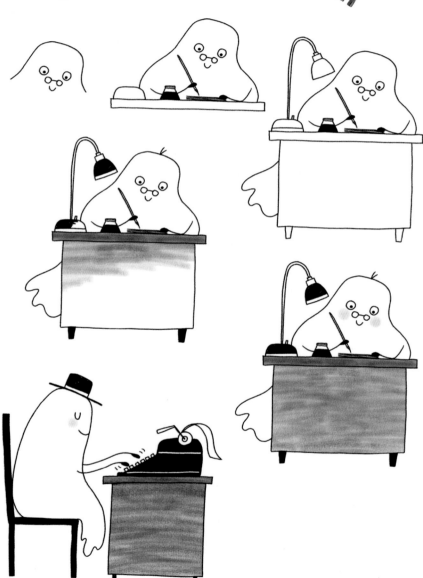

DRAW A COUCH POTATO

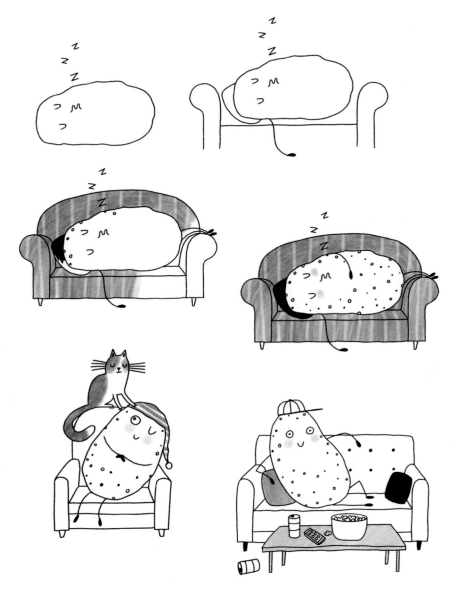

DRAW A MOVIE STAR

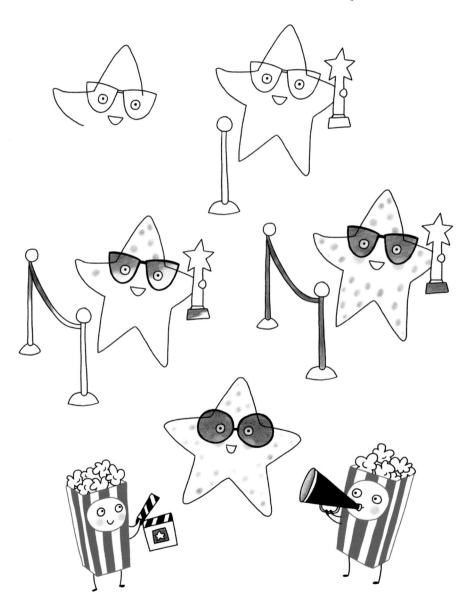

DRAW A SEA LION

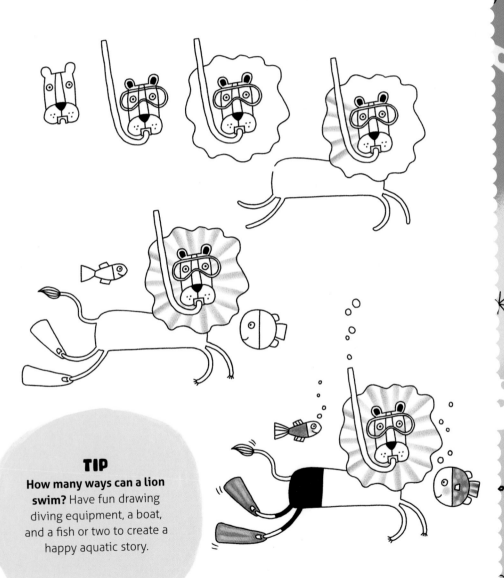

TIP
How many ways can a lion swim? Have fun drawing diving equipment, a boat, and a fish or two to create a happy aquatic story.

DRAW A VEGGIE INGENUE

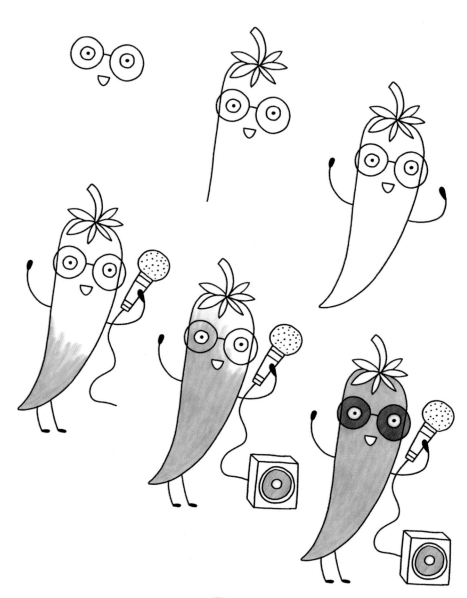

DRAW A DOG WALKER

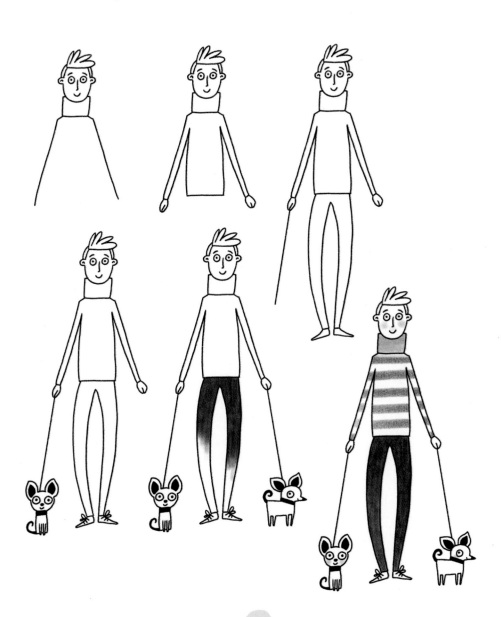

DRAW A ROBOT NERD

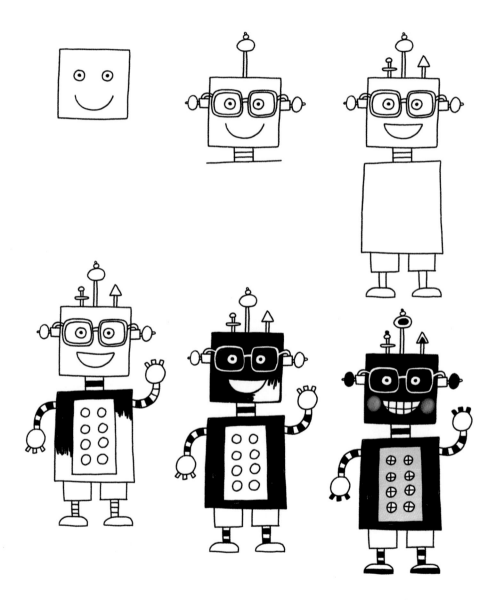

DRAW A LOVEY DOVE

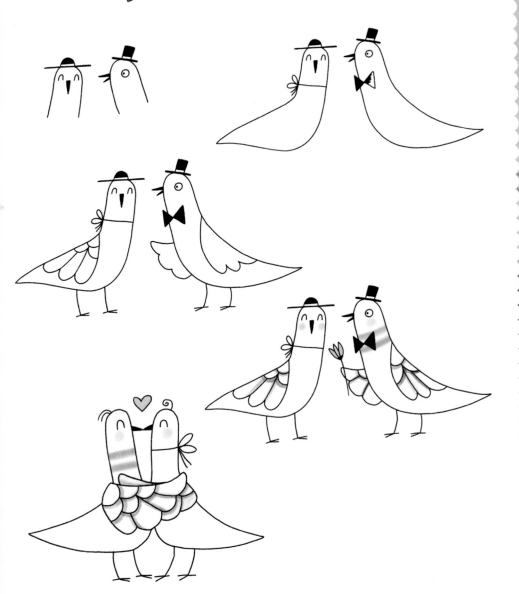

DRAW A PLANT TENDER

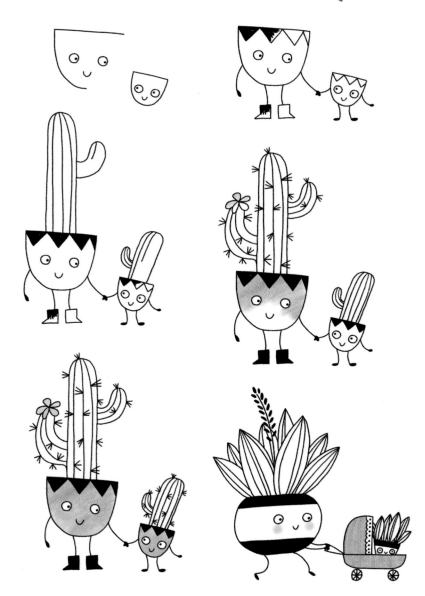

DRAW A FLYING PIG

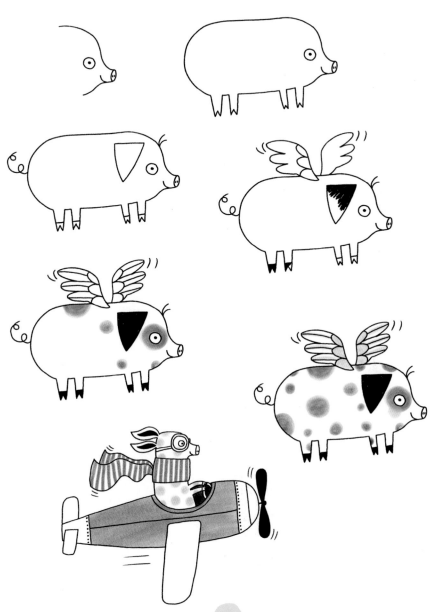

DRAW A GOOD EGG

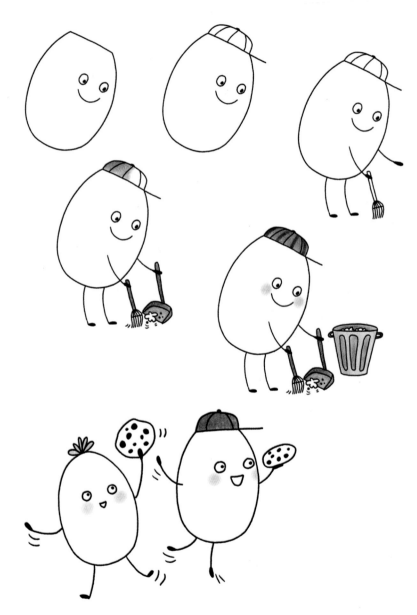

DRAW A GLEE FROG

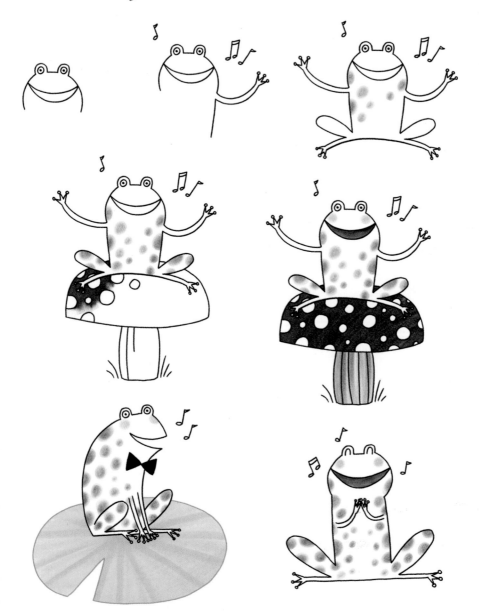

DRAW A BEACHCOMBER

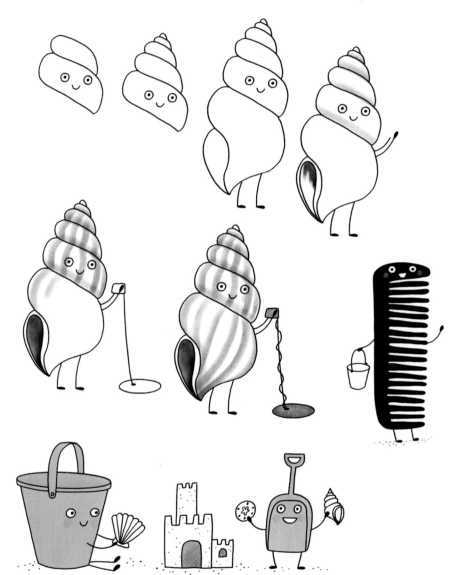

DRAW A POT HEAD

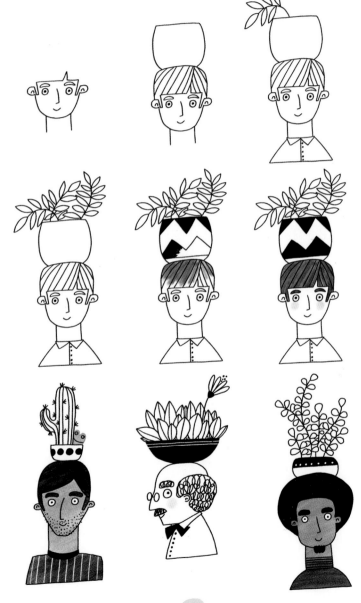

DRAW A SPACE ODDITY

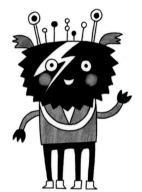
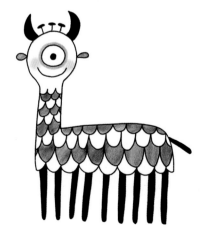
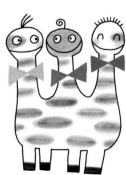
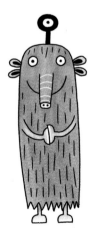

DRAW A HOBBY HORSE

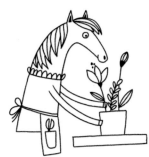

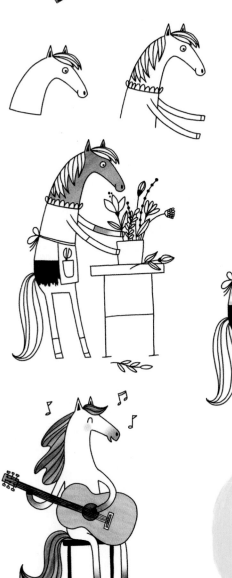

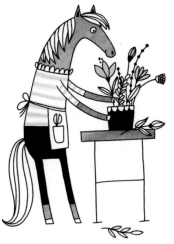

TIP
The possibilities are endless when it comes to hobbies!
Pick an animal and a hobby and get your animal creating.

DRAW A CAT BURGLAR

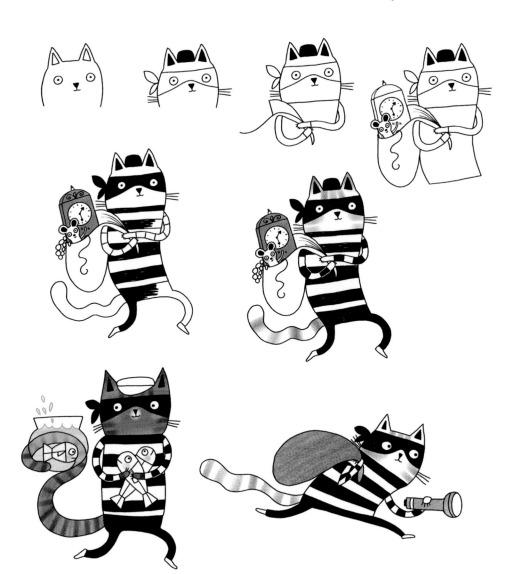

DRAW A SWEETIE PIE

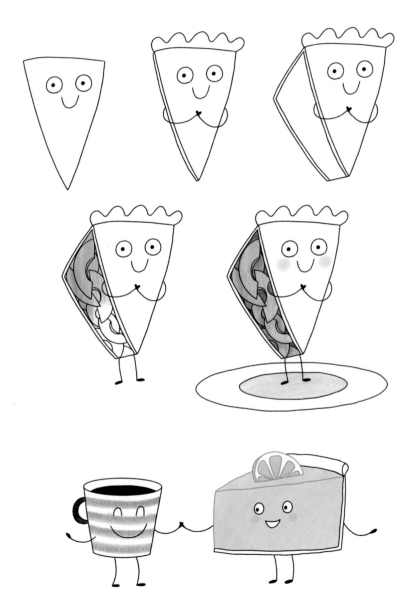

DRAW A WILD GOOSE

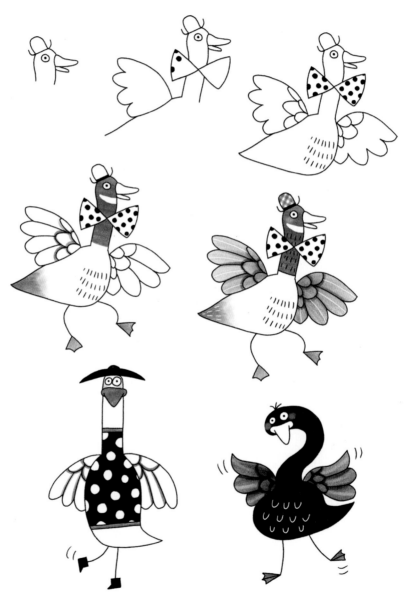

DRAW A CACTUS COWBOY

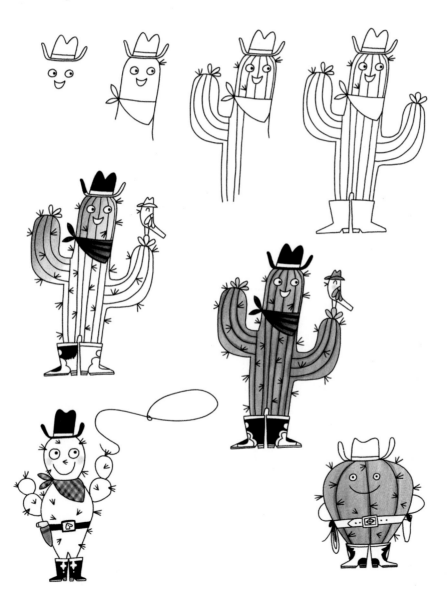

DRAW A LAB RAT

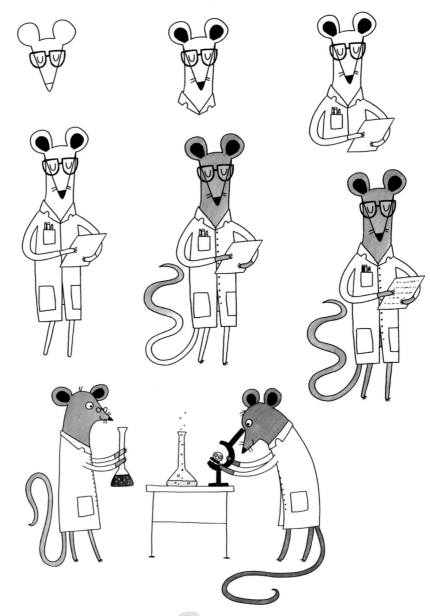

DRAW A ZEN GOUDA

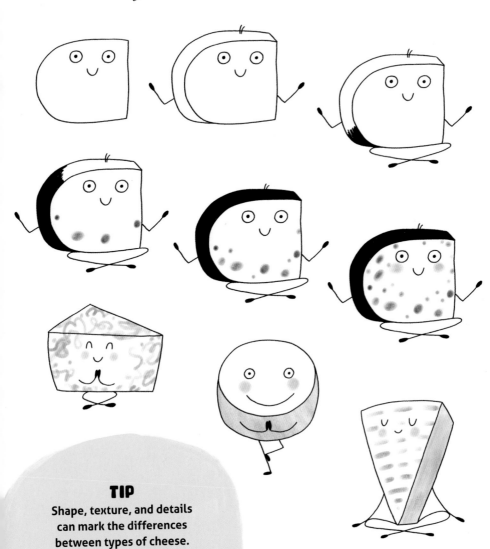

TIP
**Shape, texture, and details
can mark the differences
between types of cheese.**
How they meditate and do yoga
can make them very zen.

DRAW A VAMPIRE ACROBAT

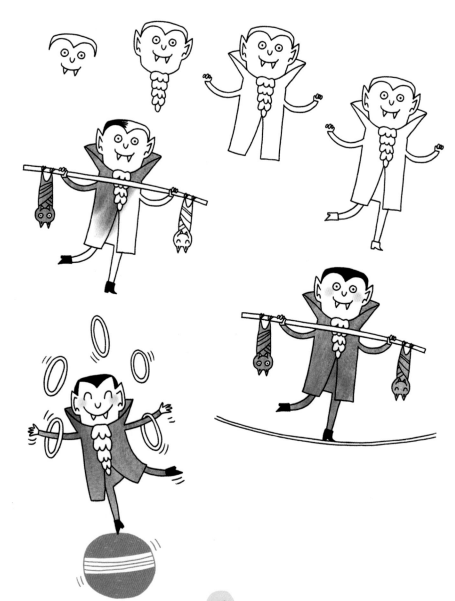

DRAW A COUNTING SHEEP

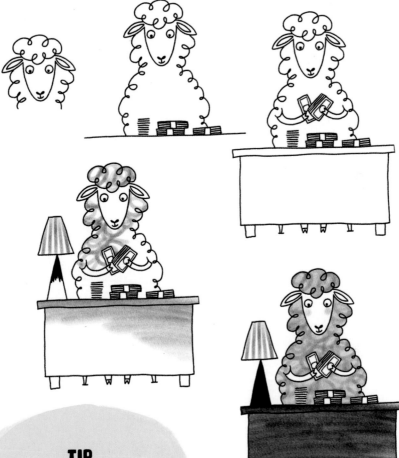

TIP
Counting is something accountants, bankers, and insomniacs often do. Think about the situations in which people count and add your characters to them.

DRAW A FIBER FANATIC

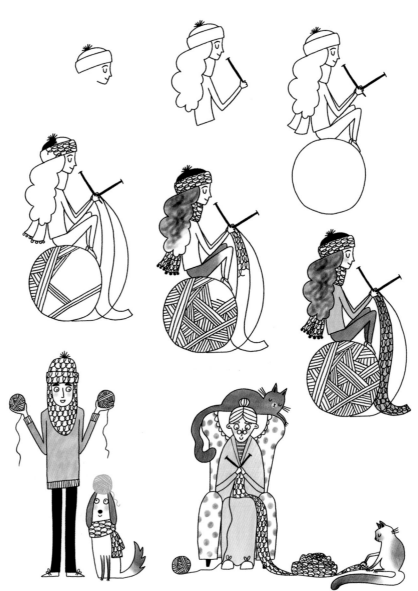

DRAW A BOOKWORM

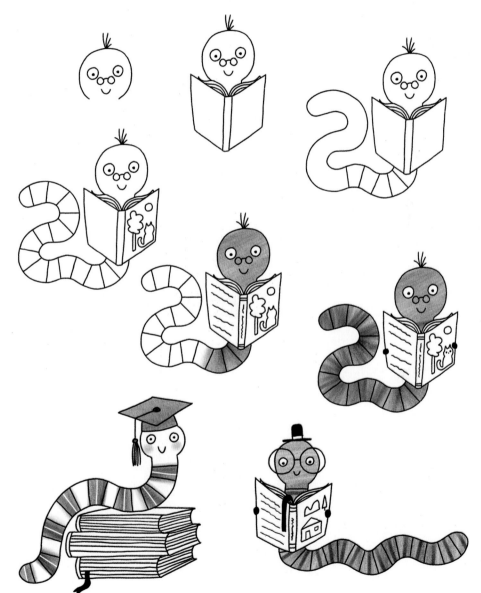

DRAW A SKATE DATE

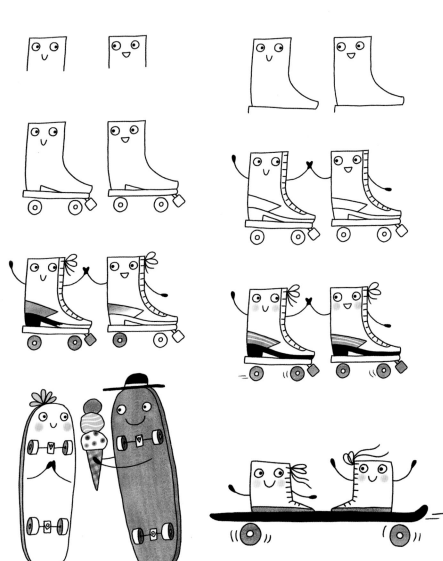

DRAW AN ANT IN PANTS

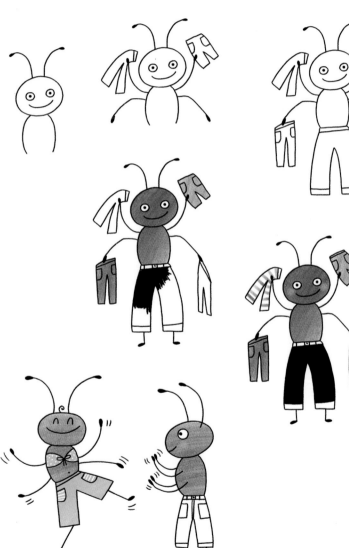

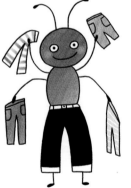

DRAW A TINY PLANET

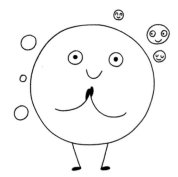
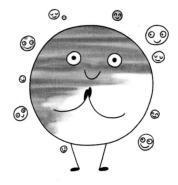
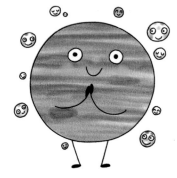
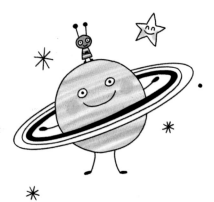
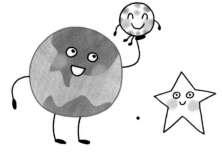

DRAW A TURKEY TROTTER

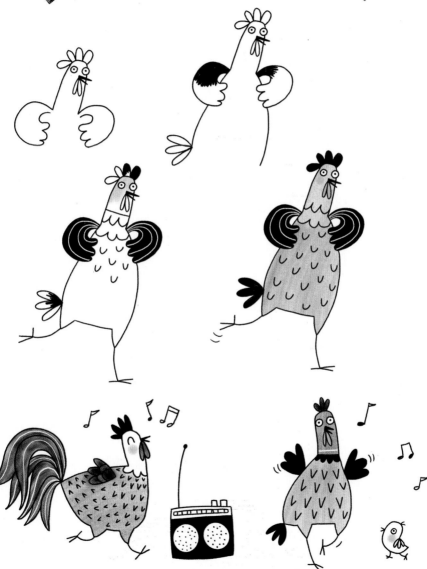

DRAW A COFFEE BEING

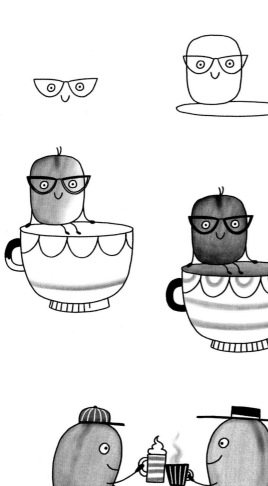
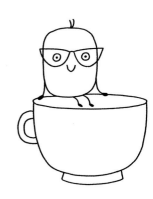
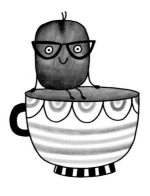

DRAW A SHERLOCK GNOME

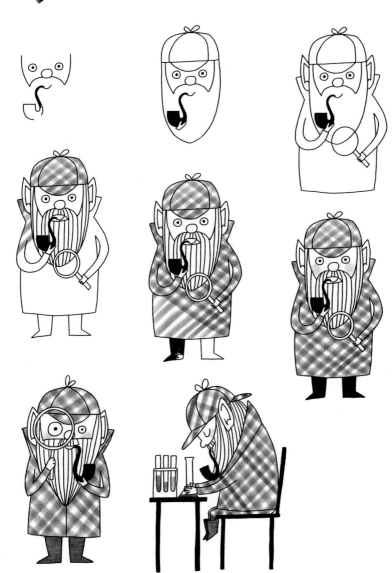

DRAW A TOP BANANA

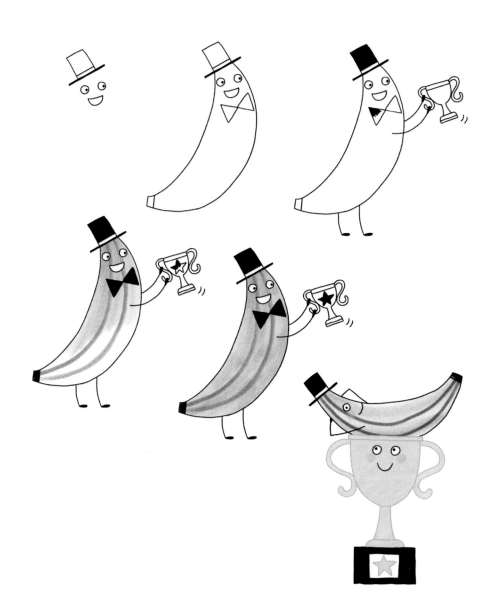

DRAW A MUSTACHE MAN

DRAW A DONUT OFFICER

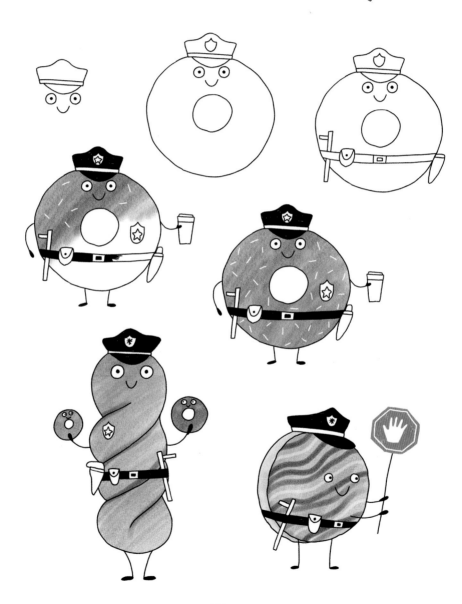

DRAW AN EARLY BIRD

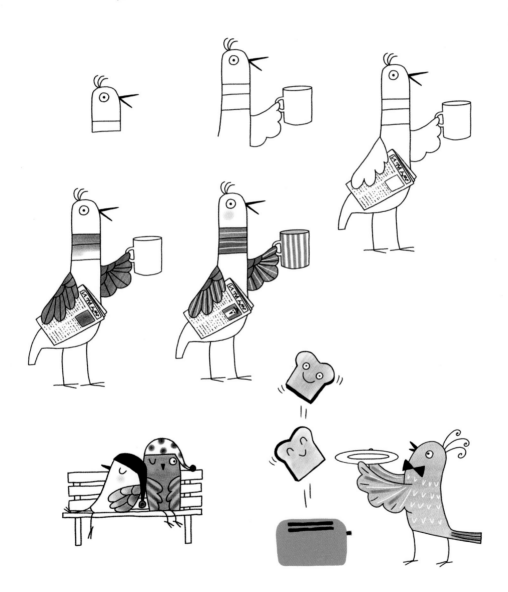

DRAW A PEACHY QUEEN

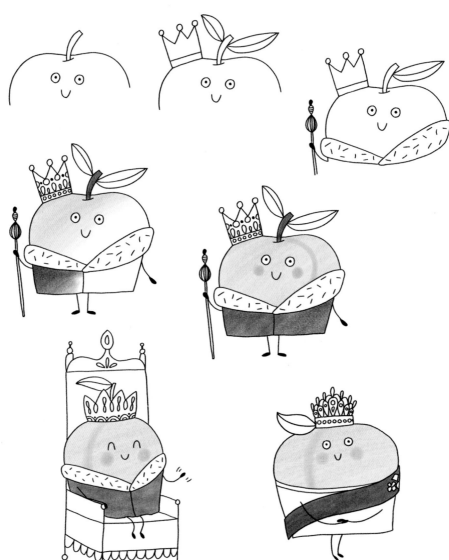

DRAW AN UNI-CYCLIST

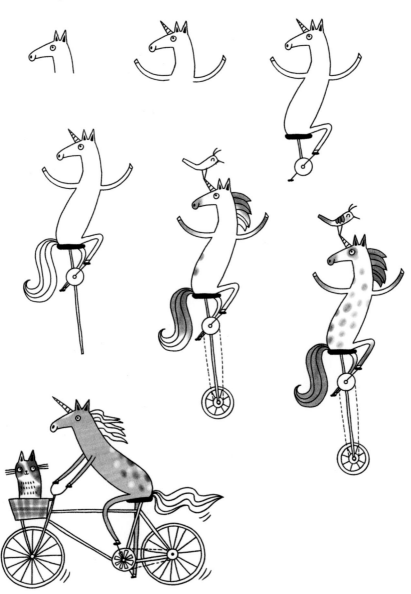

DRAW A HE-MAN MAILMAN

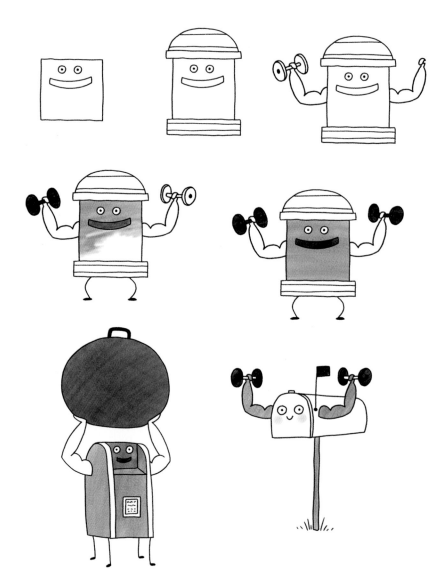

DRAW A WINE CONNOISSEUR

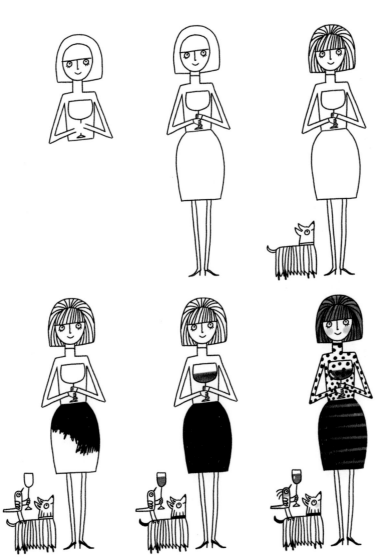

DRAW A TOUGH COOKIE

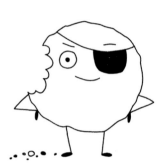
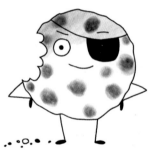
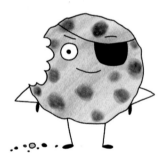
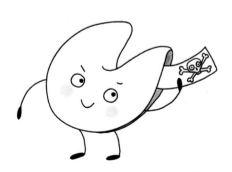
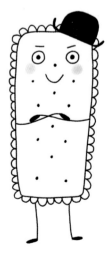

DRAW A DRAMATIC FLARE

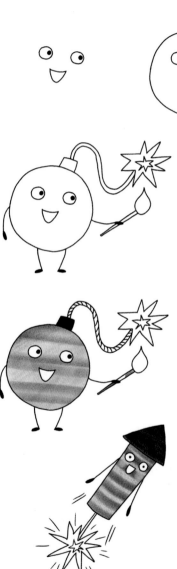

TIP

Nothing says surprise like large round eyes with the pupils in the middle. To soften the emotion, move the pupils off-center a bit (or a lot), and make the outer shape of the eyes smaller.

DRAW A GUINEA PIG

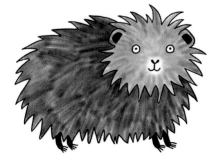

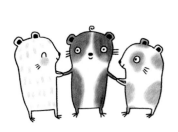

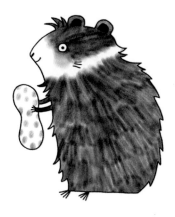

DRAW A WALRUS

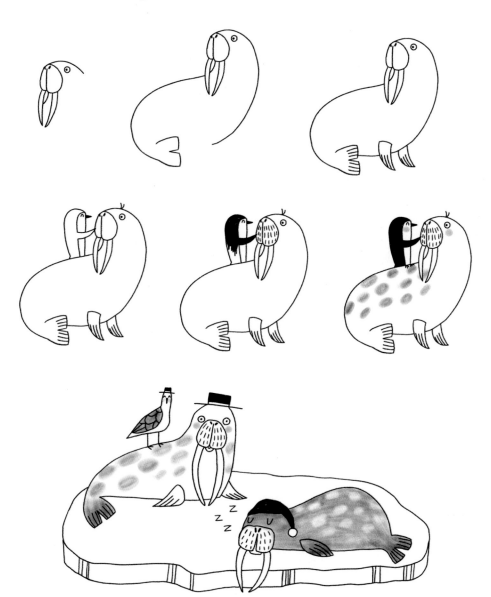

DRAW A CHAMELEON

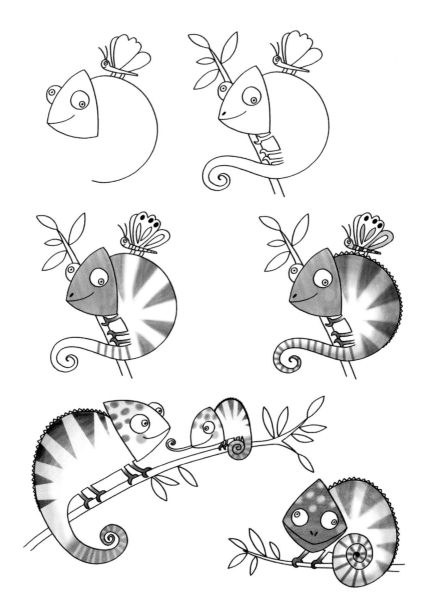

DRAW A SPOTTED DOG

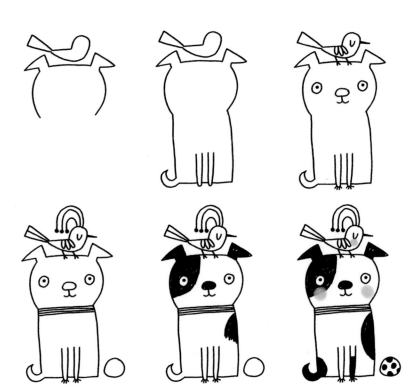

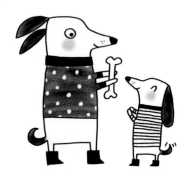

DRAW A MOUNTAIN GOAT

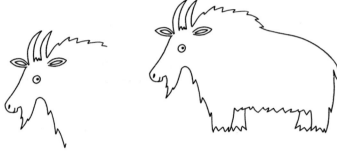

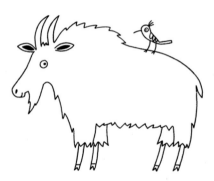

TIP
When creating happy animals, try adding baby animals into the mix, or a bird or two. Having animals interact with each other can create a happy story.

DRAW A HERMIT CRAB

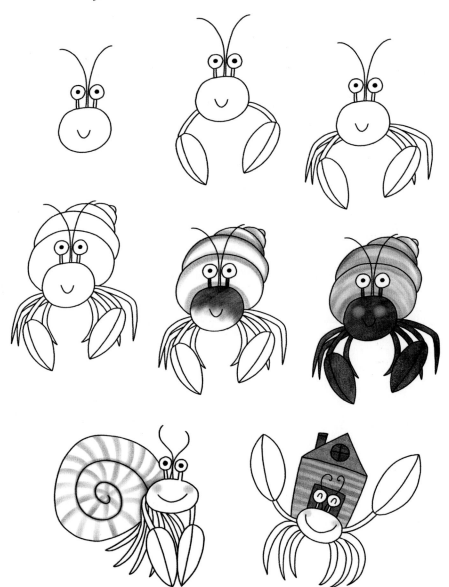

DRAW AN IGUANA

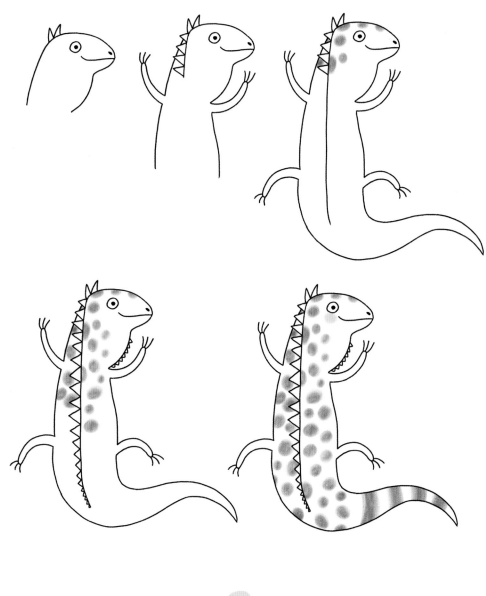

DRAW A FRUIT BAT

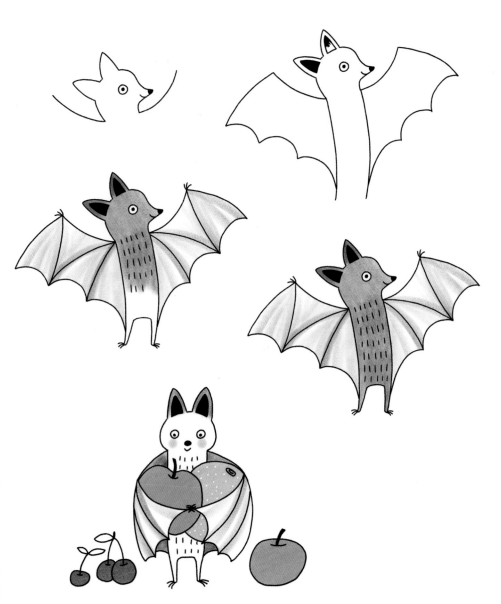

DRAW A LION

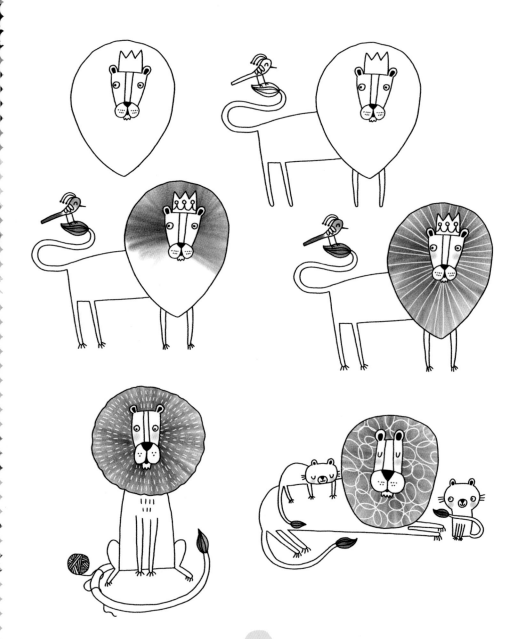

DRAW A BACKYARD BIRD

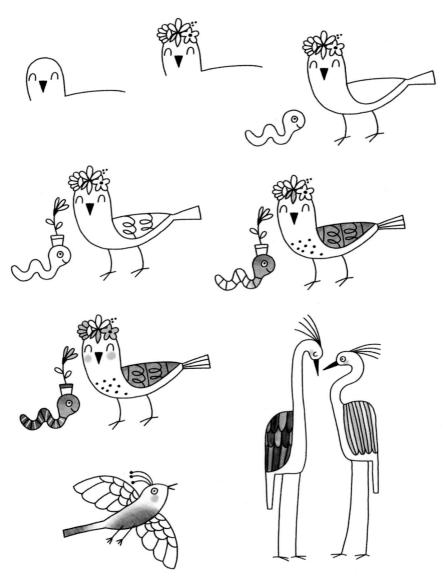

DRAW A FERRET

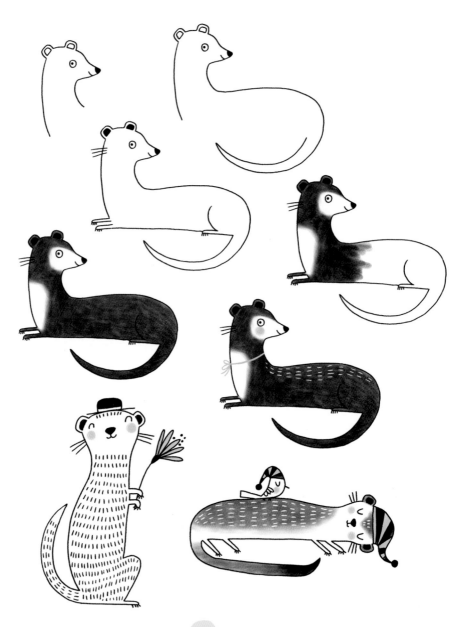

DRAW A BUTTERFLY

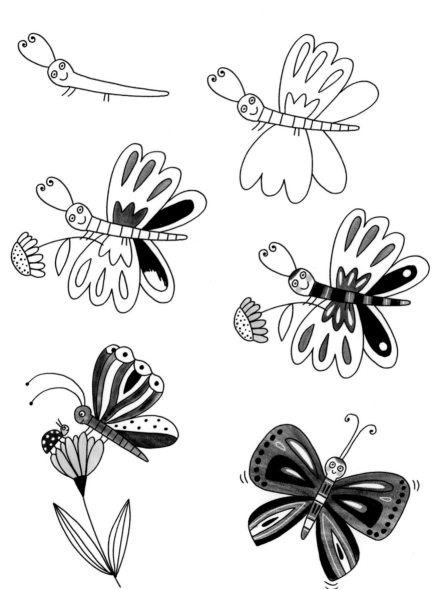

DRAW A SIFAKA LEMUR

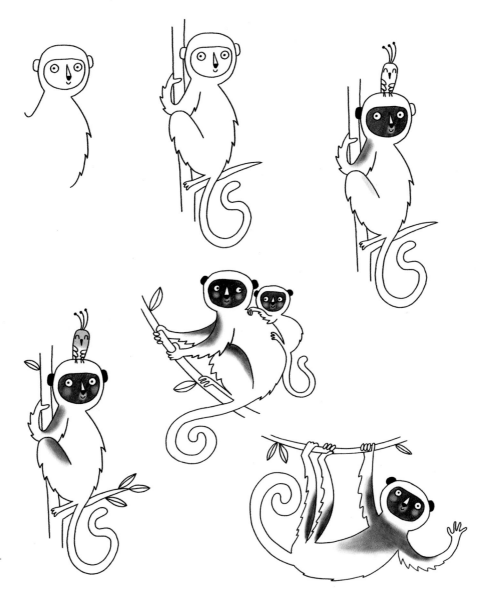

DRAW A ZEBRA

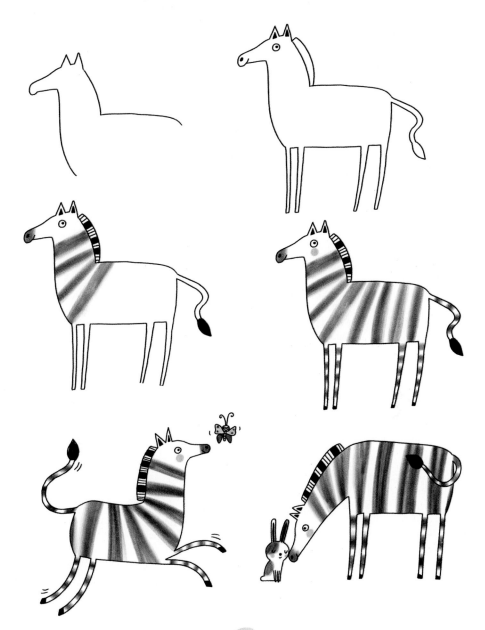

DRAW A BEAVER

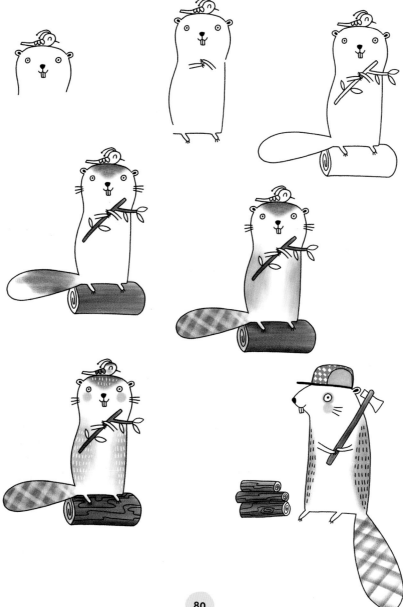

DRAW A FISH

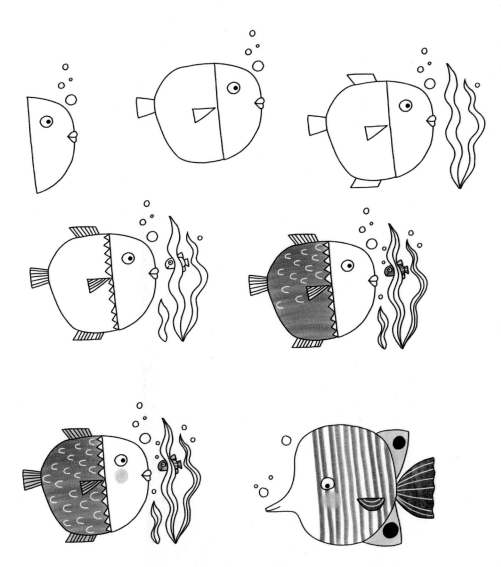

DRAW AN ALLIGATOR

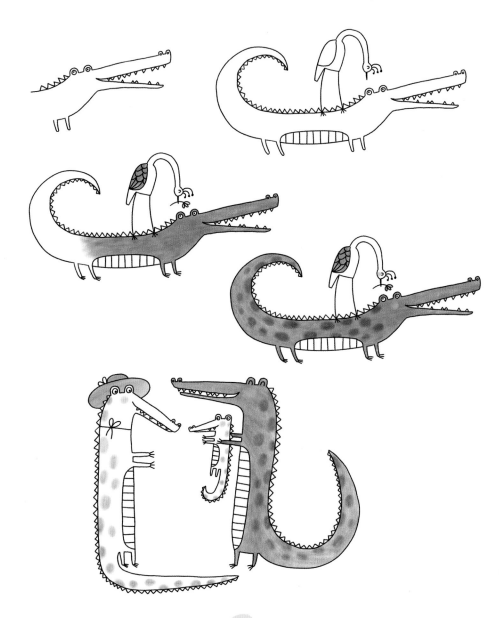

DRAW A MANED WOLF

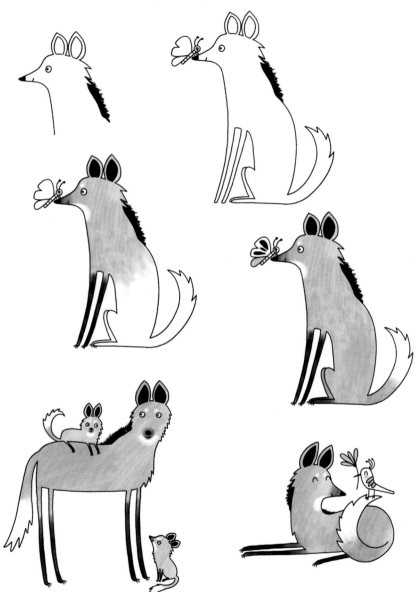

DRAW A PIGEON

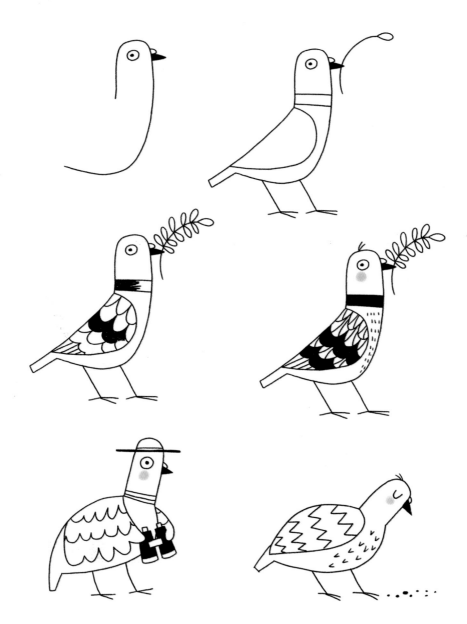

DRAW A YAK

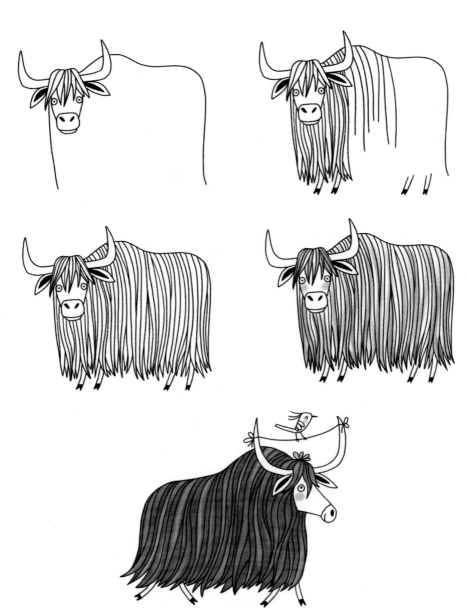

DRAW A DOLPHIN

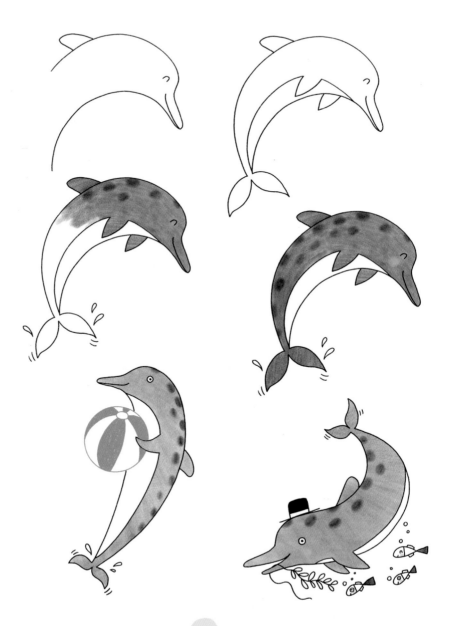

DRAW A FROG

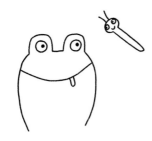

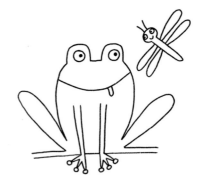

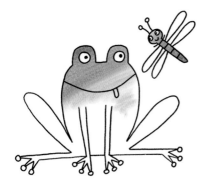

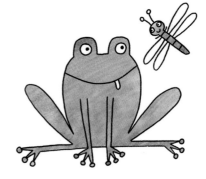

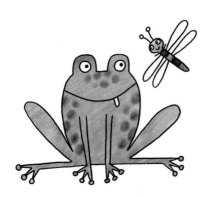

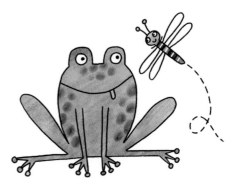

DRAW A RACCOON

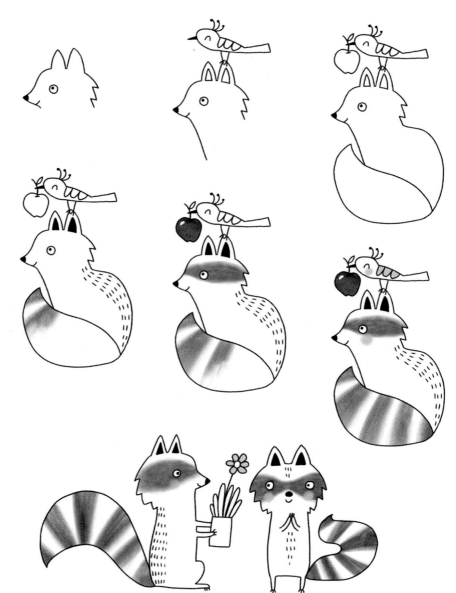

DRAW A COZY CAT

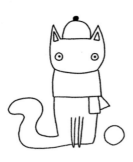

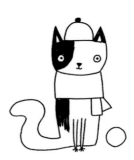

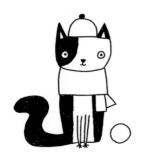

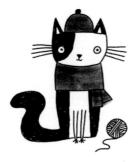

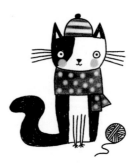

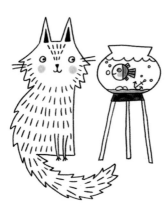

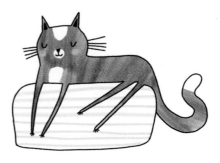

DRAW A POLAR BEAR

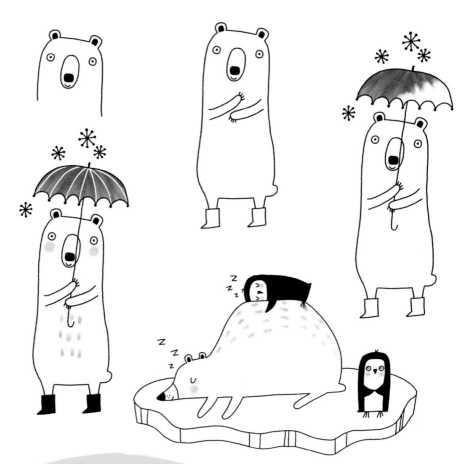

TIP
The animal's habitat can make your drawing even more recognizable and **fun!** Add an iceberg and a penguin, and your polar bear has a party!

DRAW A TASMANIAN DEVIL

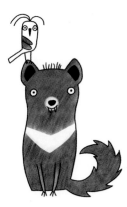

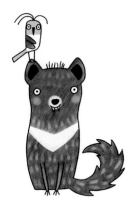

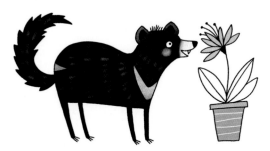

DRAW A RAM

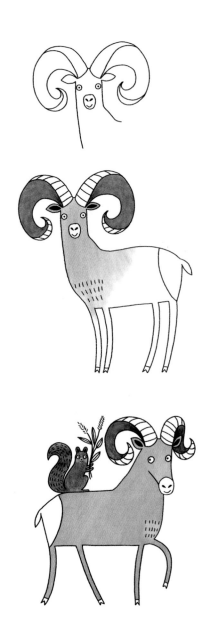
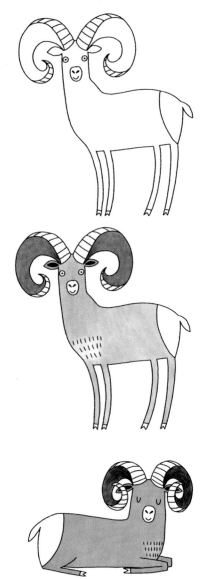

DRAW A BUNNY

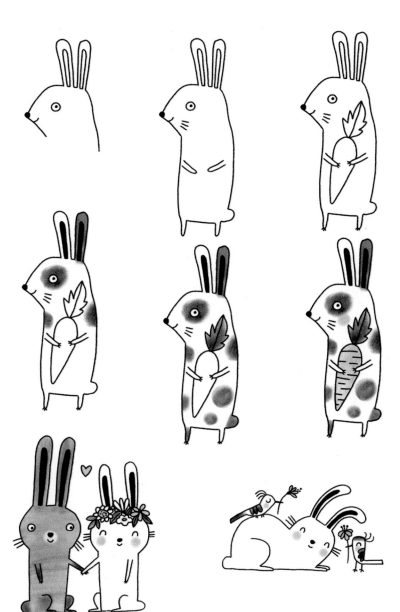

DRAW A SPIDER

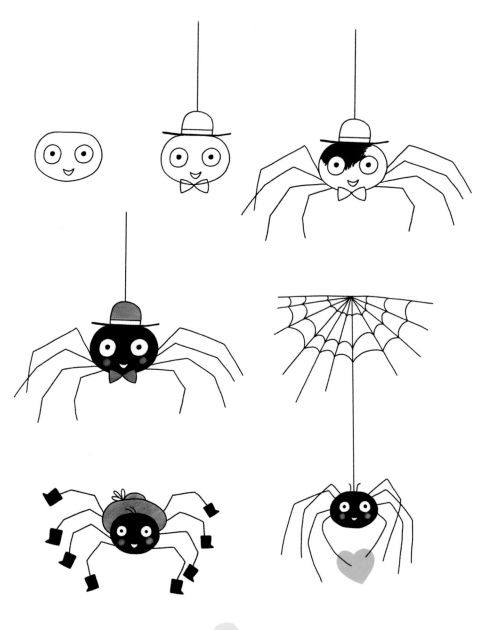

DRAW A CHEETAH

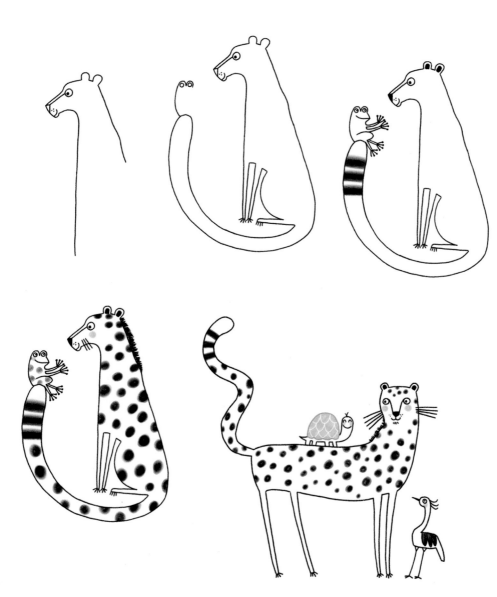

DRAW AN ANTEATER

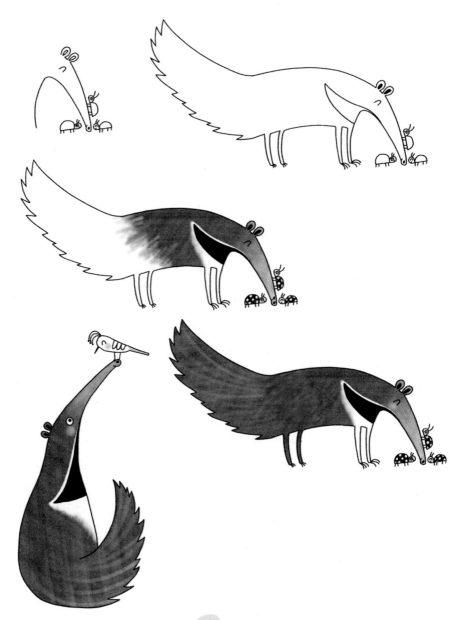

DRAW AN ORANGUTAN

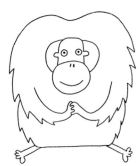

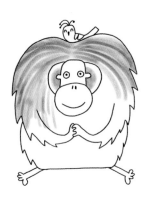

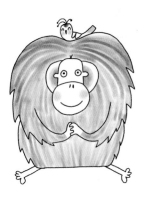

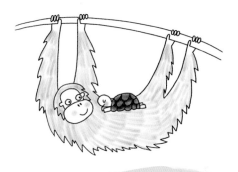

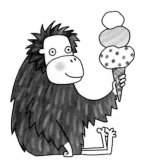

TIP

Animals with long hair are fun to draw.
Use the side of a pencil to lay the hair down in the direction it falls. Also, orangutans have hands like humans. They're great at holding ice cream cones and hanging from branches.

DRAW AN IMPALA

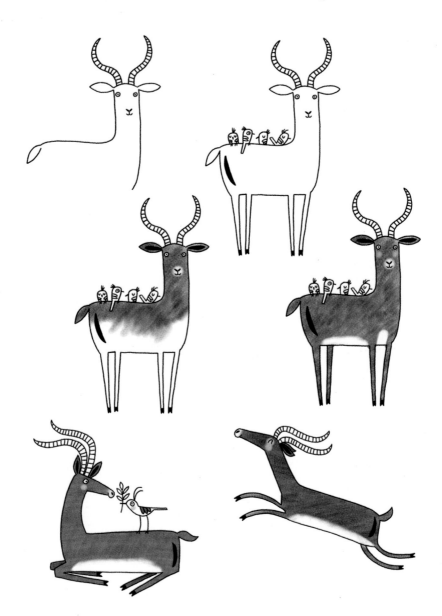

DRAW A CRAB

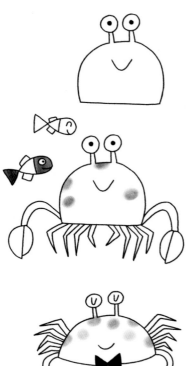

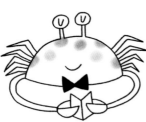

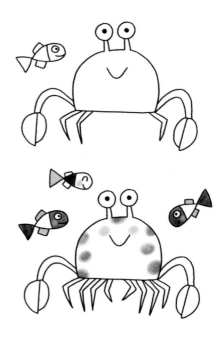

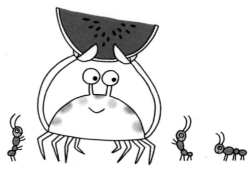

TIP
Adding little details like a bowtie, shoes, or hat can really add character to a drawing.
A little book and a bowtie can make a crab look rather sophisticated.

DRAW A MONGOOSE

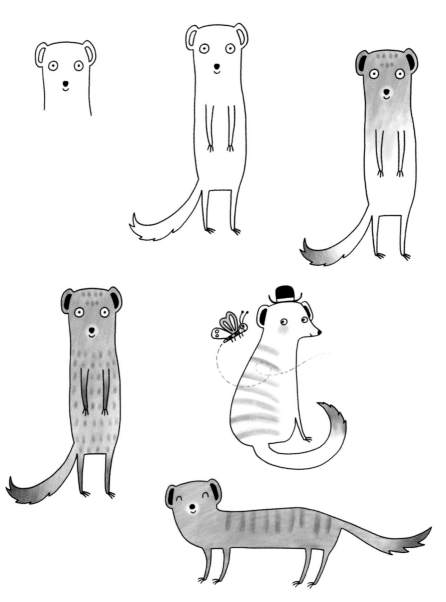

DRAW A NEWT

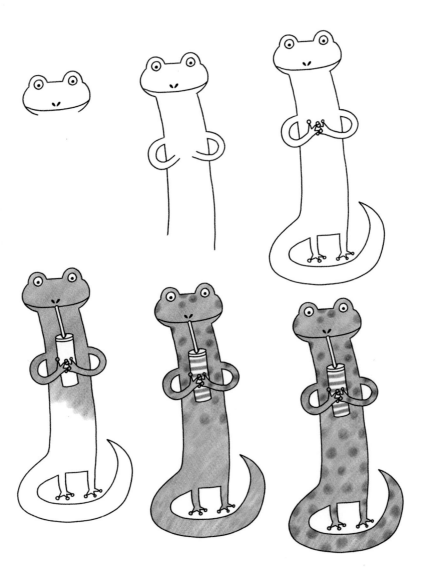

DRAW A PARROT

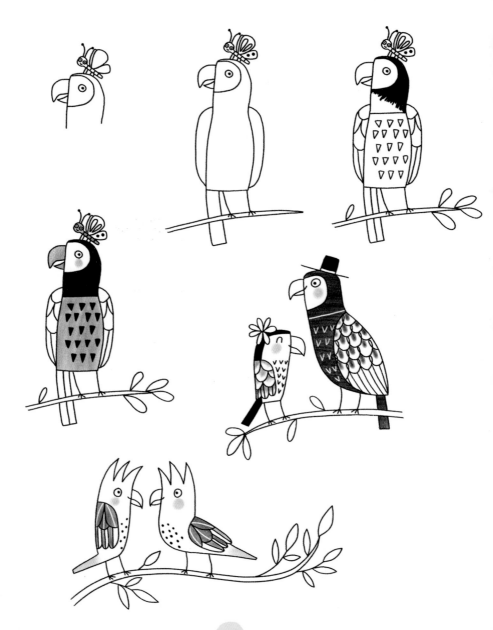

DRAW A WILD DOG

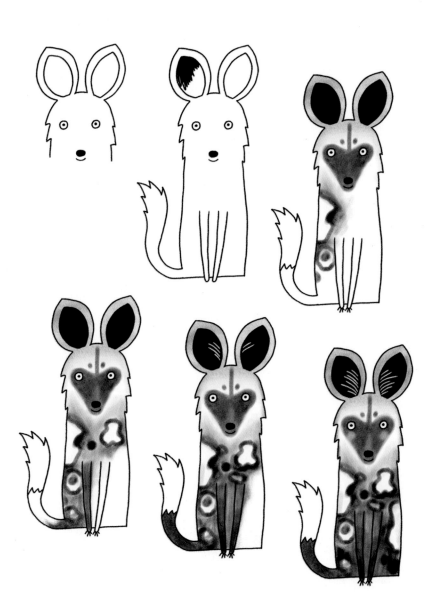

DRAW A HORSE

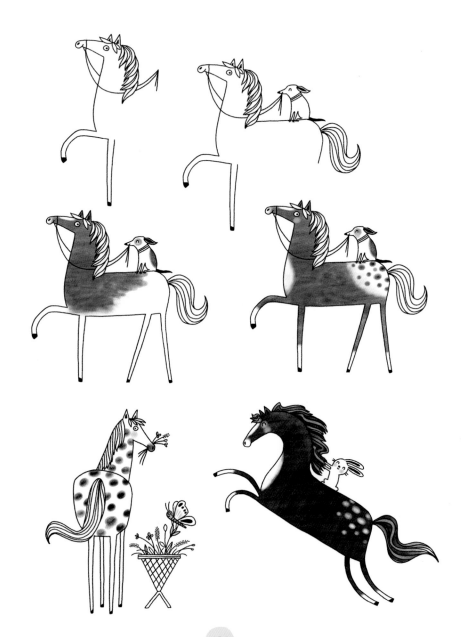

DRAW A BINTURONG

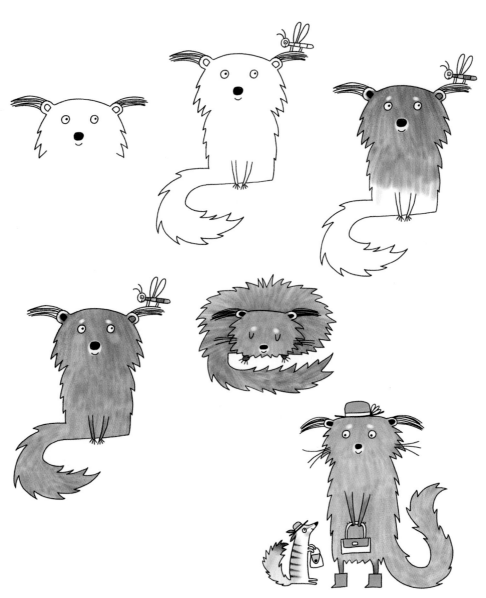

DRAW A LIZARD

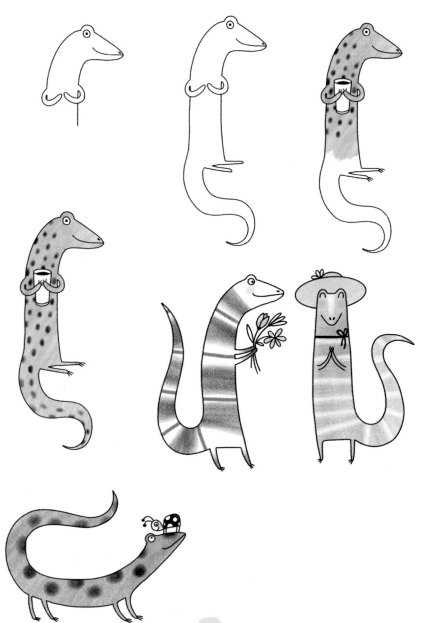

DRAW A DESIGNER DOG

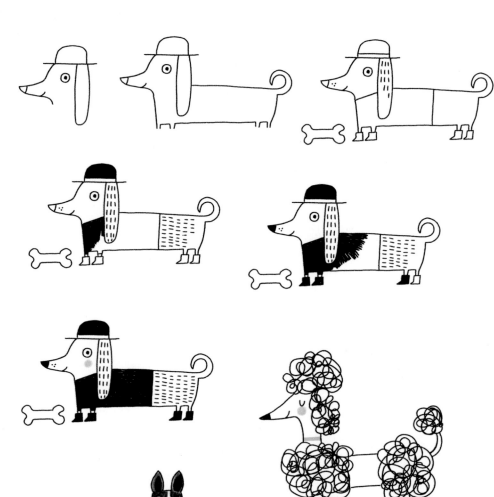

DRAW A MONKEY

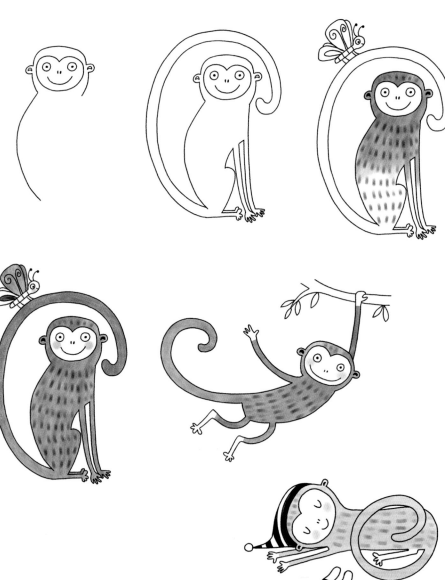

DRAW A HAMSTER

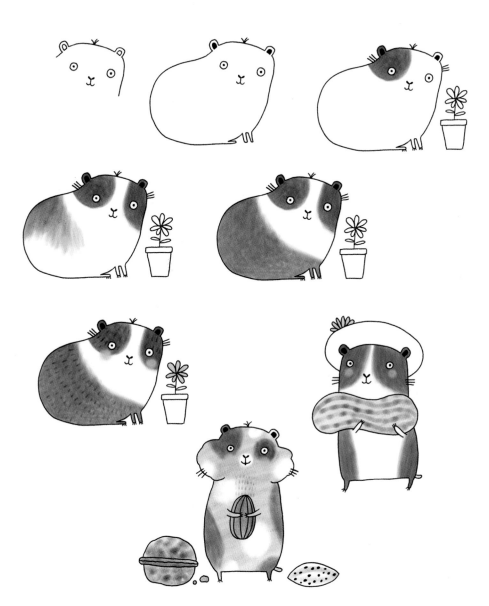

DRAW A LUNA MOTH

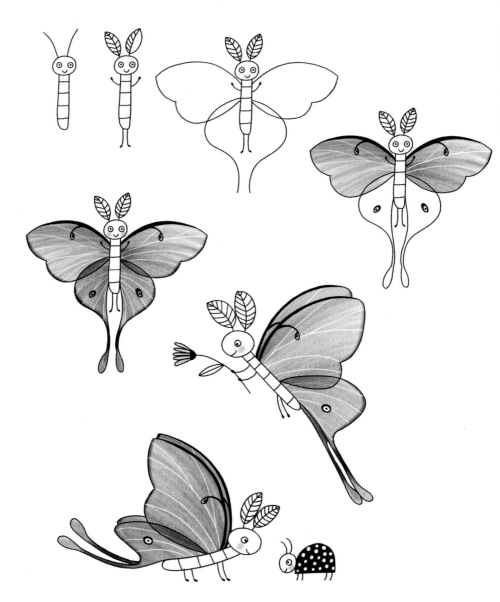

DRAW A BUSH BABY

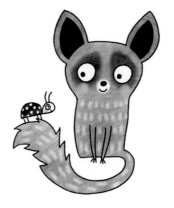

DRAW A MOOSE

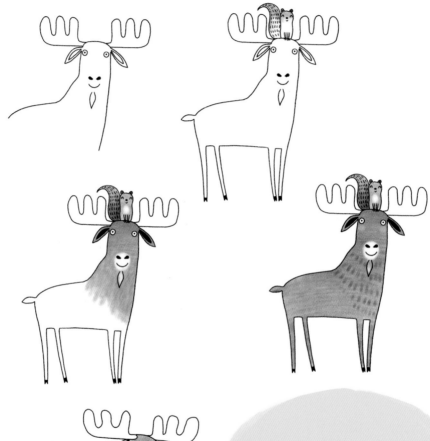

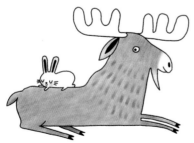

TIP

The shape of the eyes says a lot about how your animal is feeling. An upside-down U shape is a happy eye, while a right side up U can mean the animal is looking down or is sleepy.

DRAW A SPOTTED GENET

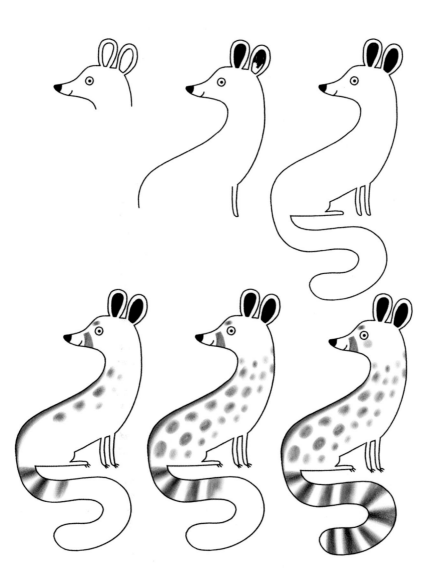

DRAW A COW

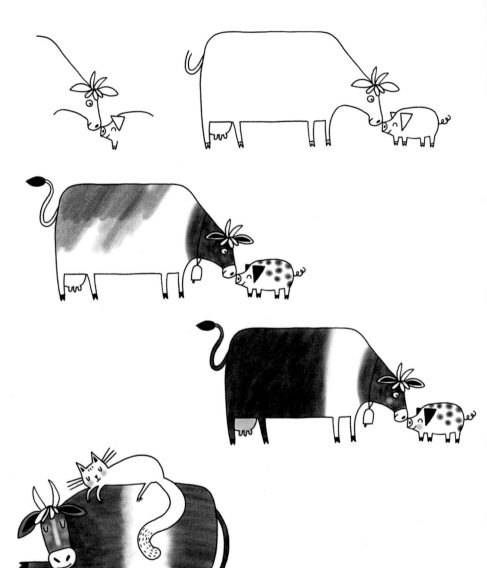

DRAW A SNAKE

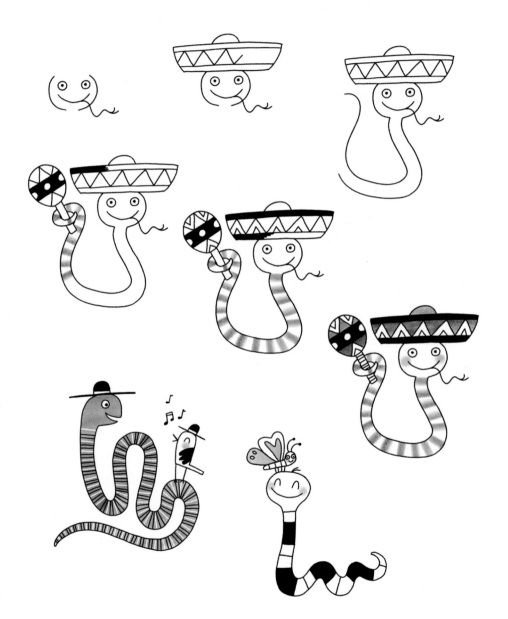

DRAW AN EMU

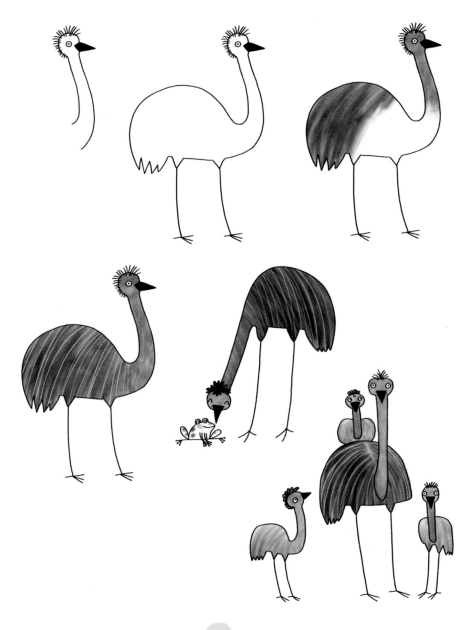

DRAW A NUMBAT

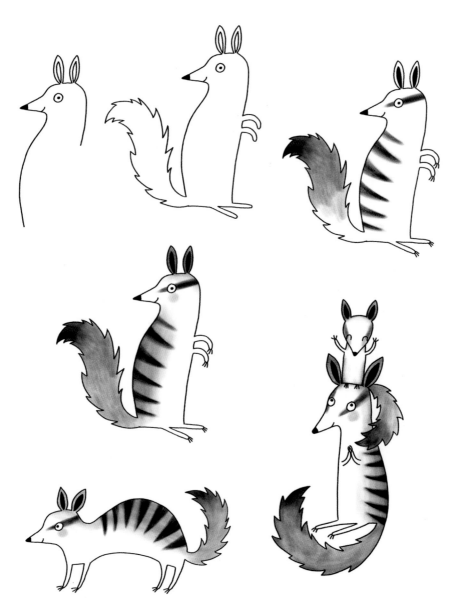

DRAW AN OKAPI

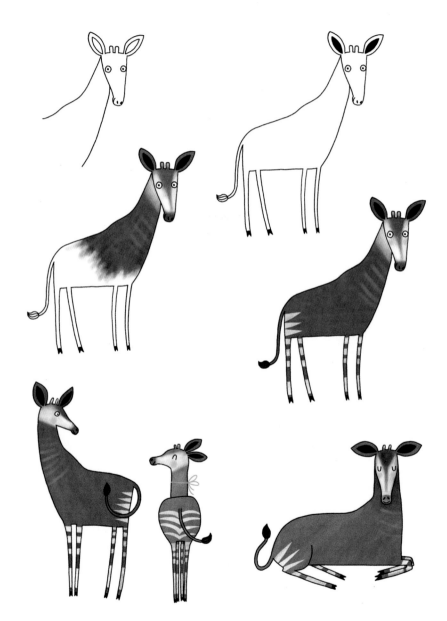

DRAW A BUSY CAT

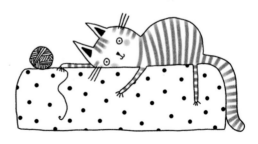

DRAW A HOOPOE BIRD

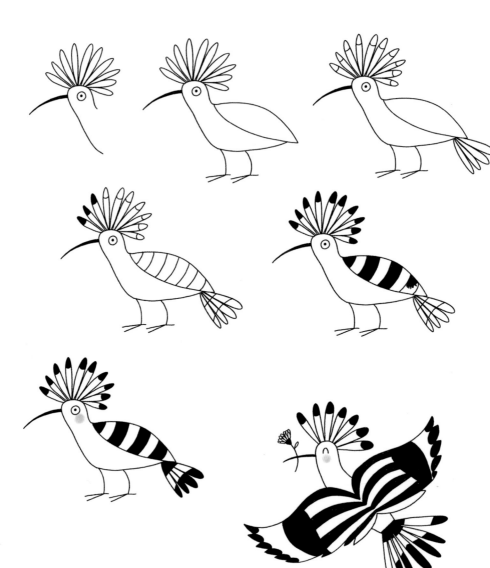

DRAW A PECCARY

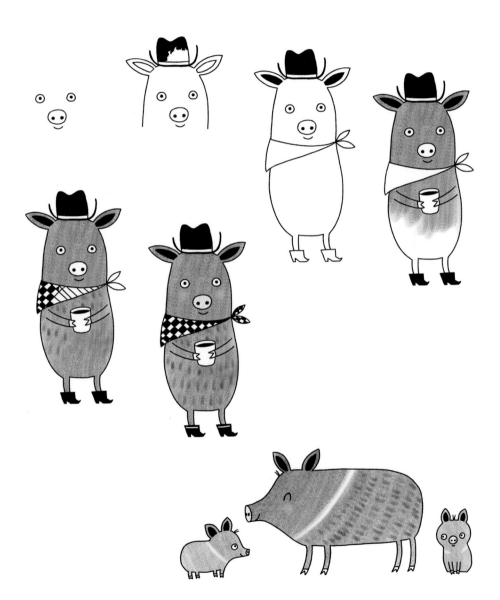

DRAW A FENNEC FOX

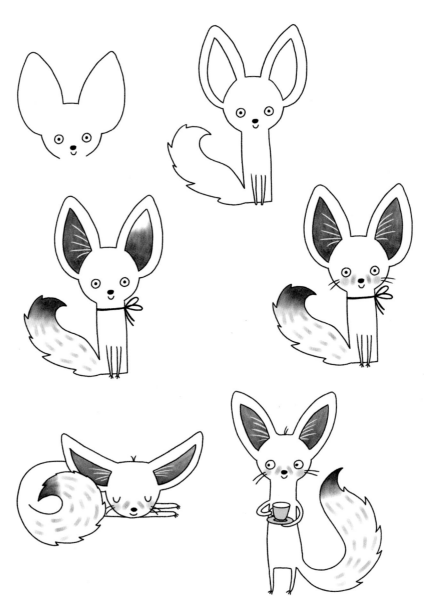

DRAW AN ASIAN BLACK BEAR

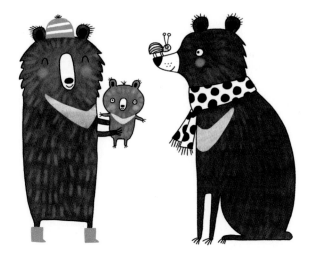

DRAW A PORCUPINE

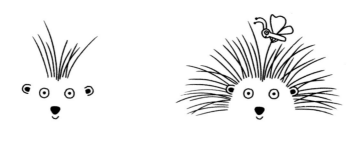

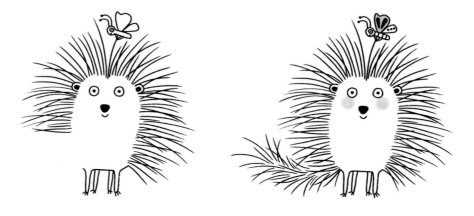

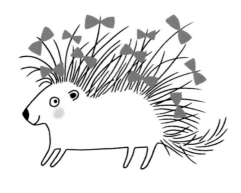

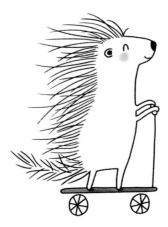

DRAW A LYNX

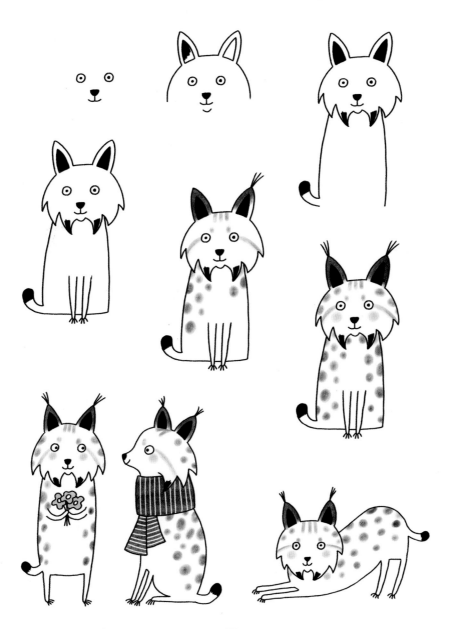

DRAW A RHINO

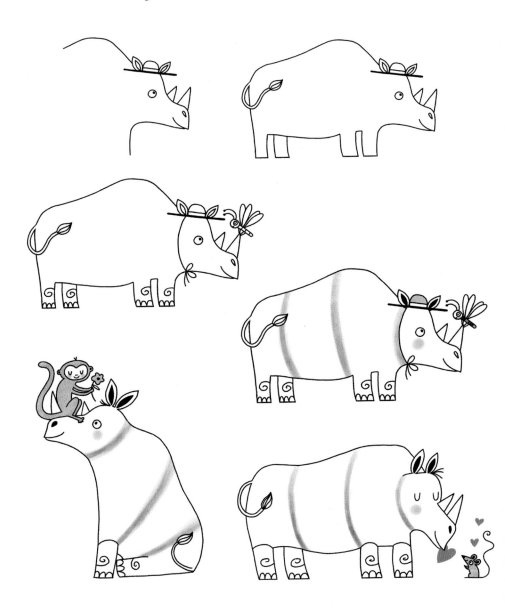

DRAW A LONG-EARED JERBOA

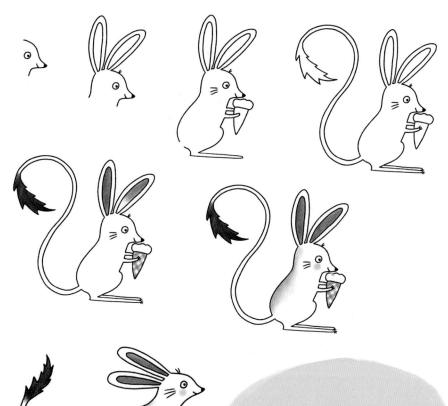

TIP
Try adding cute details to your animals to give them more personality. Matching scarves can show friendship between animals. And what animal can't be happy with a little heart to hold?

About the Author

Terry Runyan is a visual artist and creative encourager. After a long career as an in-house illustrator for Hallmark, Runyan now runs her own business, creating art and videos, presenting webinars, and leading classes to help others explore their creativity. She loves all animals, and her artwork usually includes a gathering of furry, feathery, and fishy friends. She works in a variety of mediums, including paint, collage, drawing, digital, and video. She lives in Leawood, Kansas. To see more of her work, visit her website: www.terryrunyan.com.

Quarto.com
© 2024 Quarto Publishing Group USA Inc.
Illustrations © 2020 Terry Runyan

First Published in 2024 by Quarry Books, an imprint of The Quarto Group,
100 Cummings Center, Suite 265-D, Beverly, MA 01915, USA.
T (978) 282-9590 F (978) 283-2742

Quarry Books titles are also available at discount for retail, wholesale, promotional, and bulk purchase.

For details, contact the Special Sales Manager by email at specialsales@quarto.com or by mail at The Quarto Group, Attn: Special Sales Manager, 100 Cummings Center, Suite 265-D, Beverly, MA 01915, USA.

10 9 8 7 6 5 4 3 2 1

ISBN: 978-0-7603-9238-6

Digital edition published in 2024
eISBN: 978-0-7603-9239-3

The content in this book previously appeared in *Draw 62 Animals and Make Them Happy* and *Draw 62 Characters and Make Them Happy* both published by Quarry Books in 2020 and written and illustrated by Terry Runyan.

Library of Congress Cataloging-in-Publication Data available

Design: Evelin Kasikov
Illustration: Terry Runyan

Printed in China